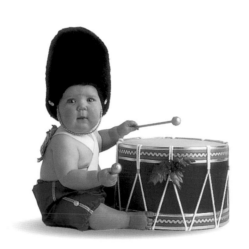

ANNE GEDDES ™

ISBN 1-7683-2004-6

© Anne Geddes 1994

Published in 1997 by Photogenique Publishers (a division of Hodder Moa Beckett)
Studio 3.16, Axis Building, 1 Cleveland Road, Parnell
Auckland, New Zealand
First published in 1997 by Hodder Moa Beckett Publishers Limited

First published in 1997 by Cedco Publishing Company,
100 Pelican Way, San Rafael, CA 94901.

First USA edition 1997
Third printing, October 1997

Props and styling by Dawn McGowan
Designed by Jane Seabrook
Produced by Kel Geddes
Color separations by MQ Imaging
Artwork by Bazz 'n' Else
Printed through Colorcraft, Hong Kong

Please write to us for a FREE FULL COLOR catalog of our fine Anne Geddes
calendars and books, Cedco Publishing Company, 100 Pelican Way,
San Rafael, CA 94901.

Visit our website: www.cedco.com

The Twelve Days of Christmas

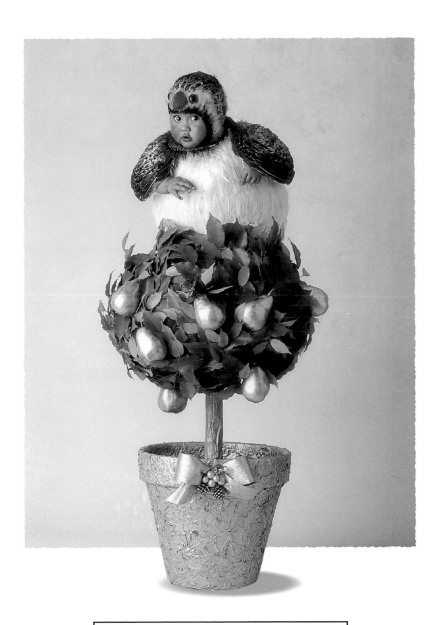

ANNE GEDDES

On the first day of Christmas,
My true love gave to me,

A partridge in a pear tree.

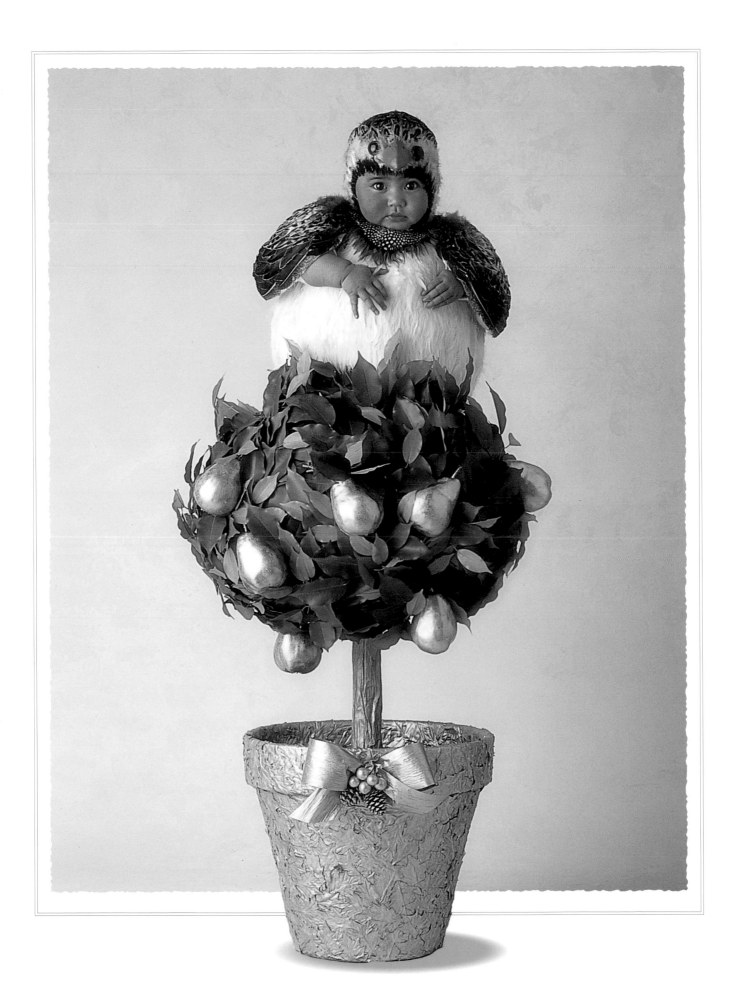

On the second day of Christmas,
My true love gave to me,

Two turtledoves,
And a partridge in a pear tree.

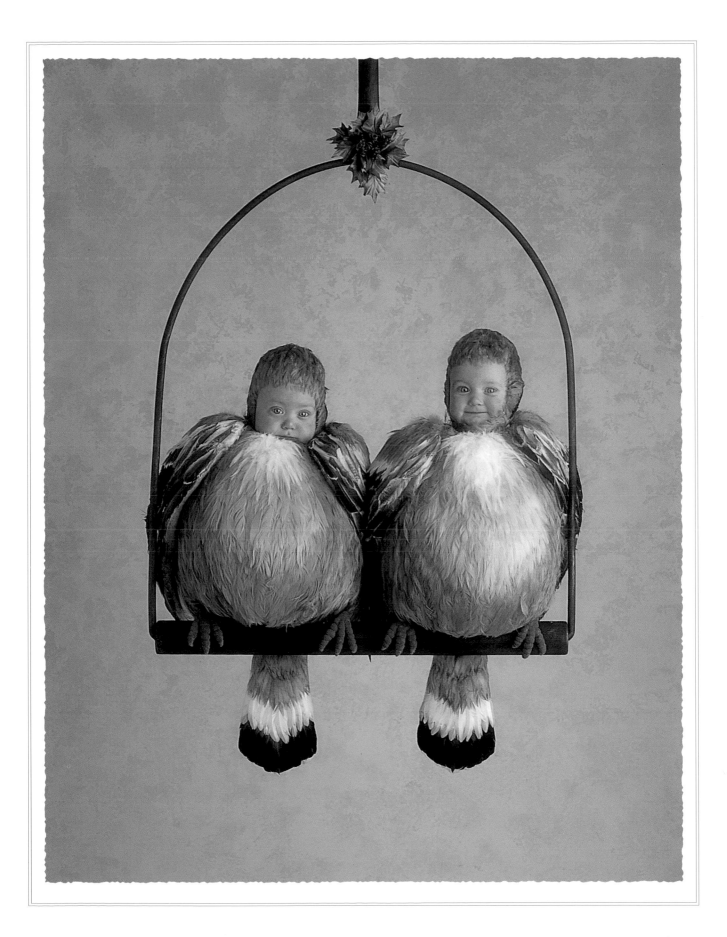

On the third day of Christmas,
My true love gave to me,

Three French hens,
Two turtledoves,
And a partridge in a pear tree.

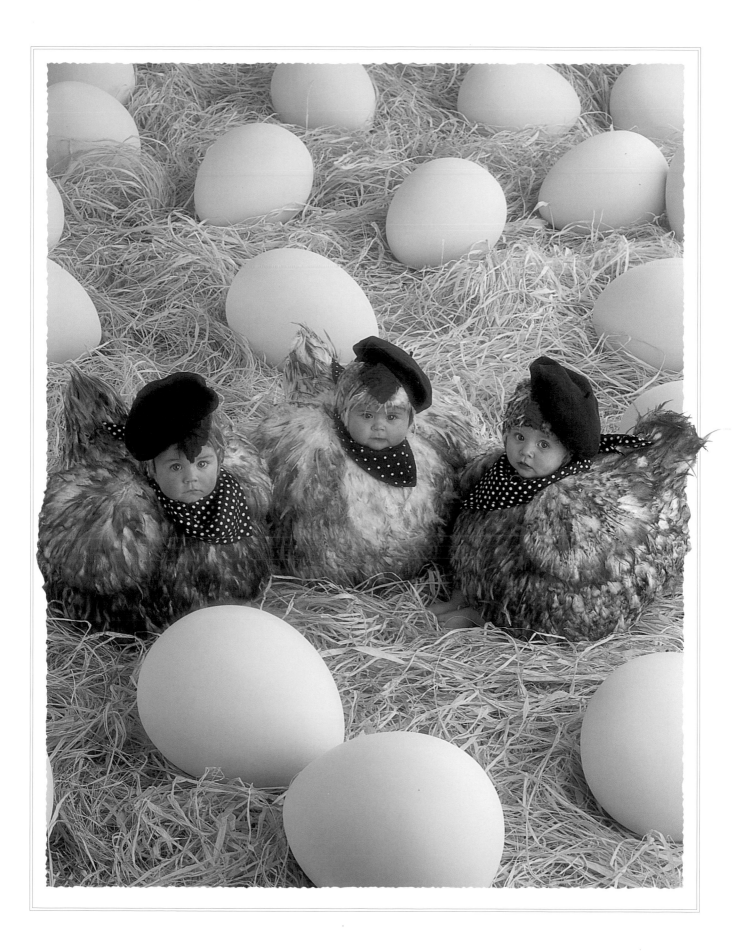

On the fourth day of Christmas,
My true love gave to me,

Four calling birds,
Three French hens,
Two turtledoves,
And a partridge in a pear tree.

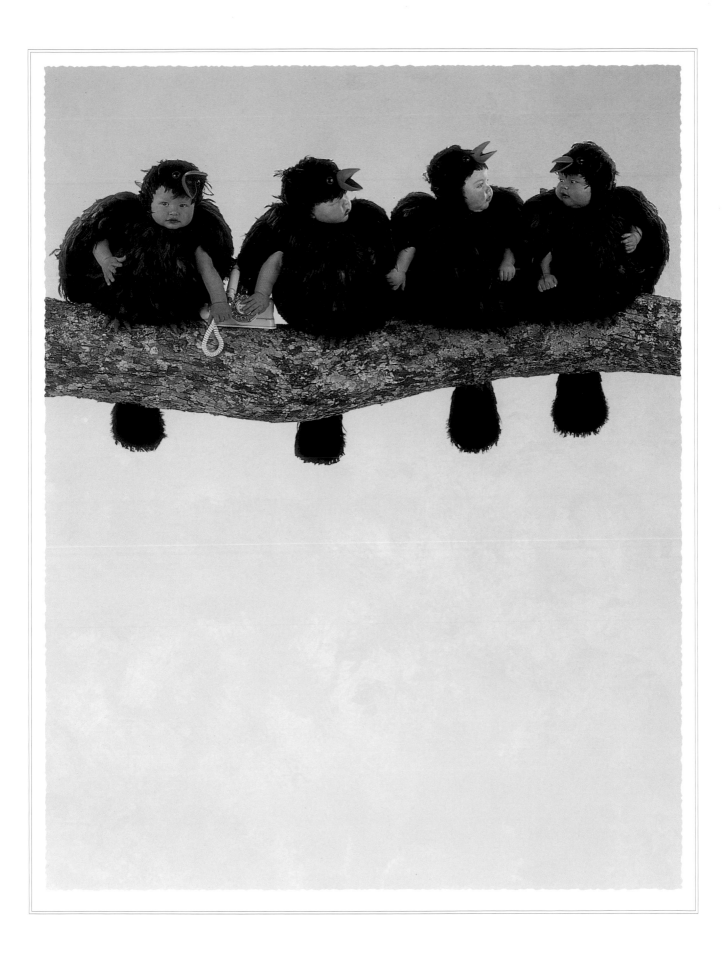

On the fifth day of Christmas,
My true love gave to me,

Five gold rings,
Four calling birds,
Three French hens,
Two turtledoves,
And a partridge in a pear tree.

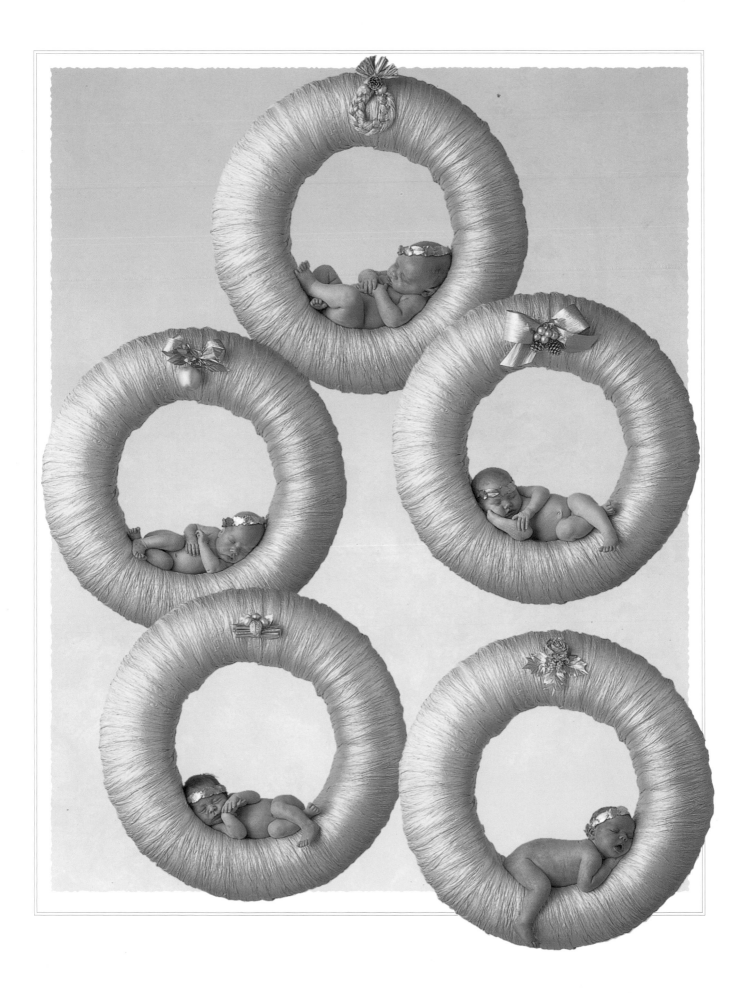

On the sixth day of Christmas,
My true love gave to me,

Six geese a-laying,
Five gold rings,
Four calling birds,
Three French hens,
Two turtledoves,
And a partridge in a pear tree.

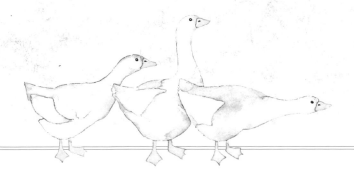

On the *seventh* day of Christmas,
My true love gave to me,

Seven swans a-swimming,
Six geese a-laying,
Five gold rings,
Four calling birds,
Three French hens,
Two turtledoves,
And a partridge in a pear tree.

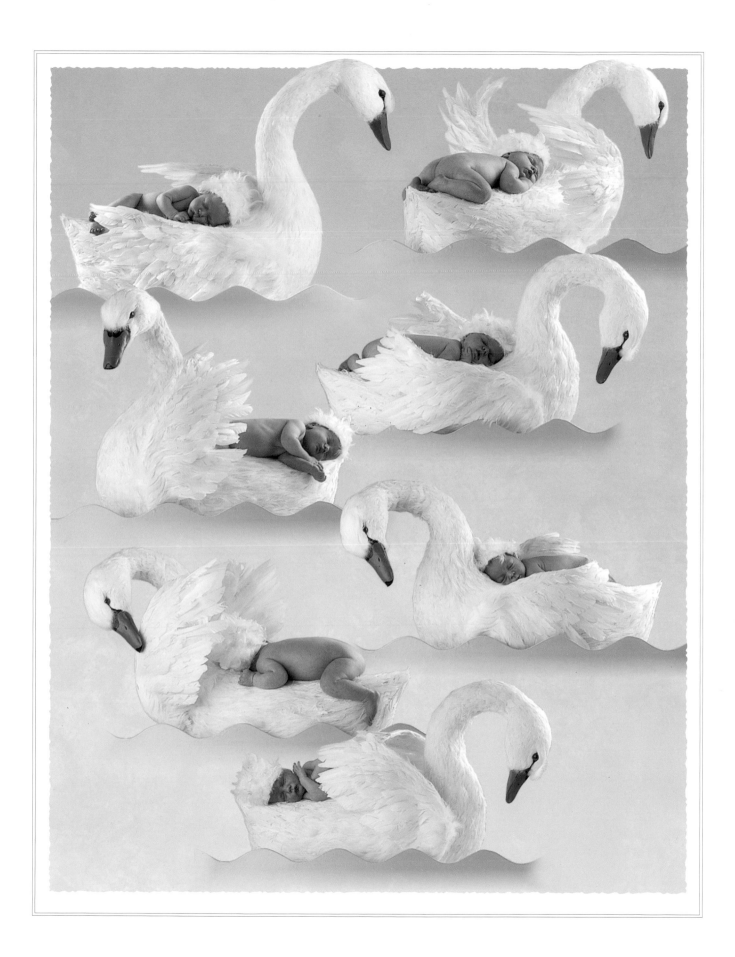

On the eighth day of Christmas,
My true love gave to me,

Eight maids a-milking,
Seven swans a-swimming,
Six geese a-laying,
Five gold rings,
Four calling birds,
Three French hens,
Two turtledoves,
And a partridge in a pear tree.

On the ninth day of Christmas,
My true love gave to me,

Nine ladies dancing,
Eight maids a-milking,
Seven swans a-swimming,
Six geese a-laying,
Five gold rings,
Four calling birds,
Three French hens,
Two turtledoves,
And a partridge in a pear tree.

On the tenth day of Christmas,
My true love gave to me,

Ten lords a-leaping,
Nine ladies dancing,
Eight maids a-milking,
Seven swans a-swimming,
Six geese a-laying,
Five gold rings,
Four calling birds,
Three French hens,
Two turtledoves,
And a partridge in a pear tree.

On the eleventh day of Christmas,
My true love gave to me,

Eleven pipers piping,
Ten lords a-leaping,
Nine ladies dancing,
Eight maids a-milking,
Seven swans a-swimming,
Six geese a-laying,
Five gold rings,
Four calling birds,
Three French hens,
Two turtledoves,
And a partridge in a pear tree.

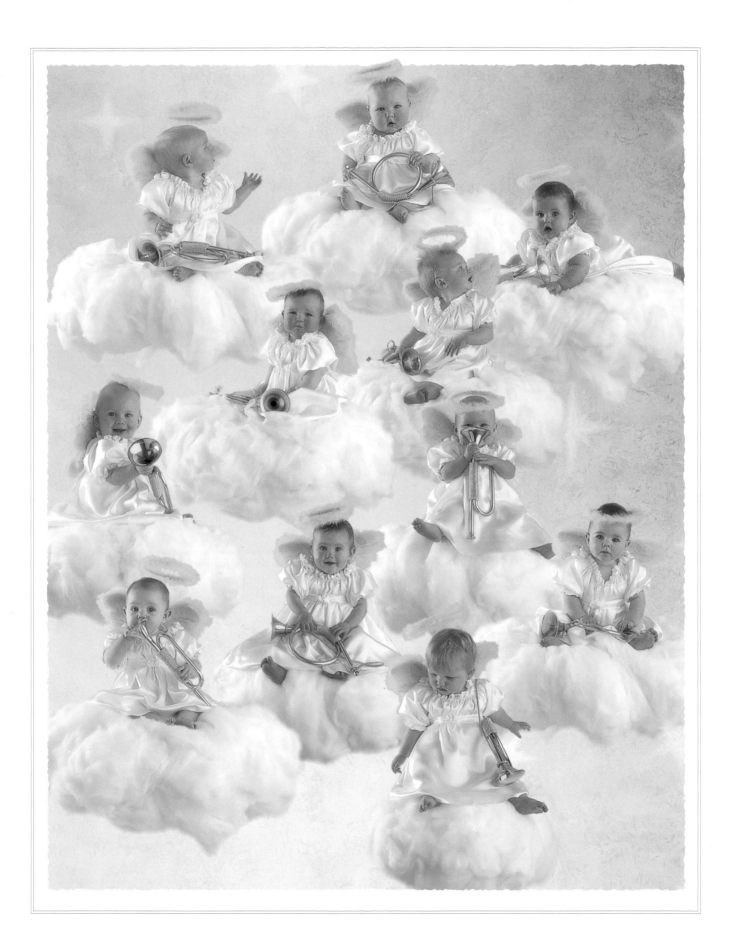

On the twelfth day of Christmas,
My true love gave to me,

Twelve drummers drumming,
Eleven pipers piping,
Ten lords a-leaping,
Nine ladies dancing,
Eight maids a-milking,
Seven swans a-swimming,
Six geese a-laying,
Five gold rings,
Four calling birds,
Three French hens,
Two turtledoves,
And a partridge in a pear tree.

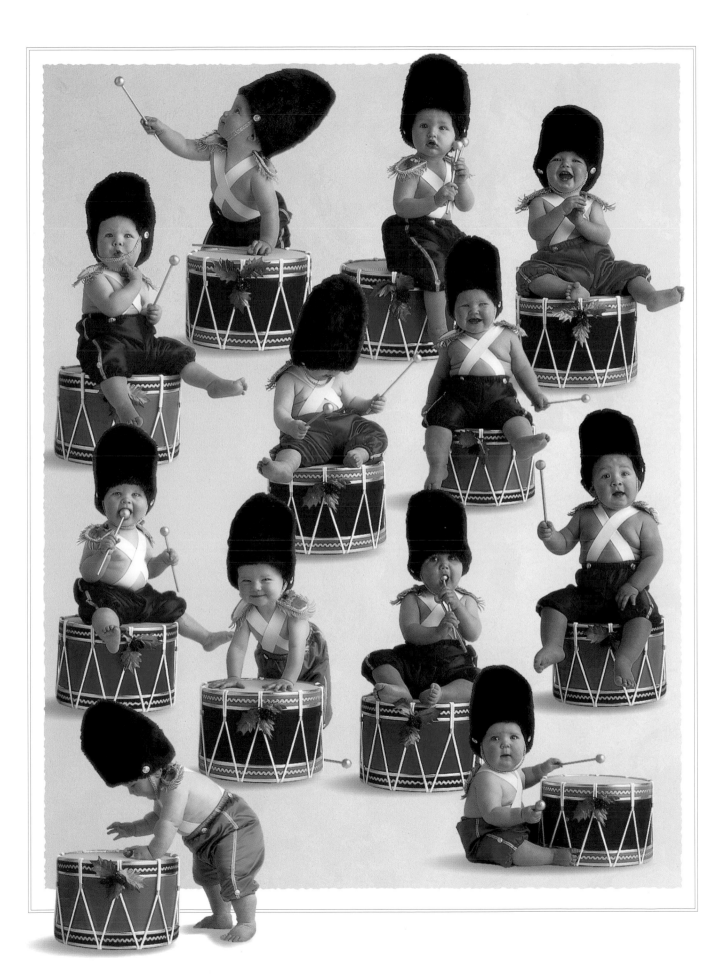

On the twelfth day of Christmas,
My true love gave to me,

Twelve drummers drumming,

Eleven pipers piping,

Ten lords a-leaping,

Nine ladies dancing,

Eight maids a-milking,

Seven swans a-swimming,

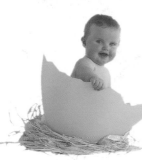

Six geese a-laying,

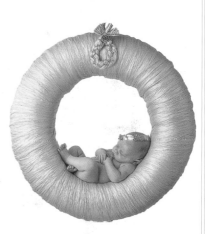

Five gold rings,

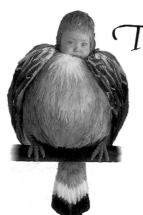

Four calling birds,

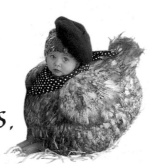

Three French hens,

Two turtledoves,

And a partridge

in a pear tree.

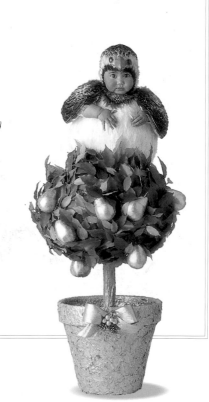

The Twelve Days of Christmas

1. On the first day of Christ-mas my true love gave to me a

par-tridge ___ in a pear tree. 2. On the se-cond day of Christ-mas my

true love gave to me two tur-tle doves and a par-tridge ___ in a pear

tree. 3. On the third day of Christ-mas my true love gave to me

three French ___ hens, two tur-tle doves and a par-tridge ___ in a pear

tree. 4. On the fourth day of Christ-mas my true love gave to me

four cal-ling birds, three French ___ hens two tur-tle doves and a

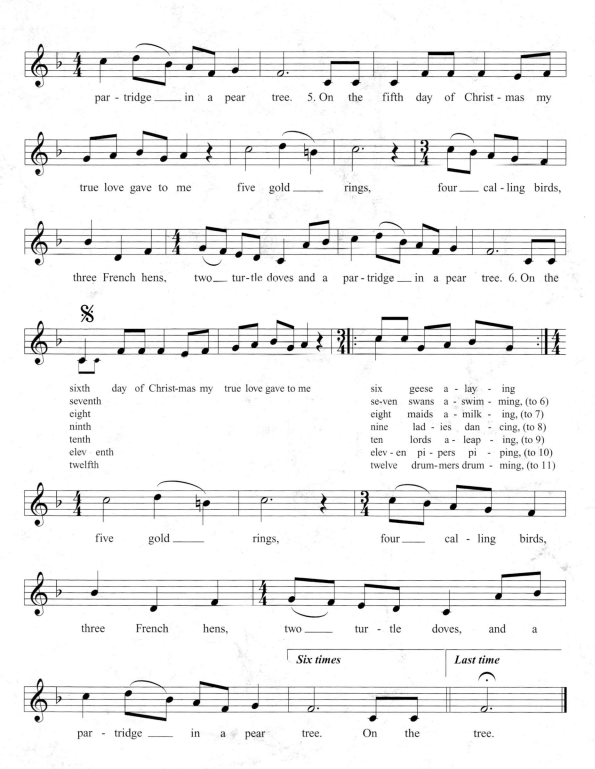

par - tridge ___ in a pear tree. 5. On the fifth day of Christ - mas my

true love gave to me five gold ___ rings, four ___ cal - ling birds,

three French hens, two ___ tur - tle doves and a par - tridge ___ in a pear tree. 6. On the

sixth day of Christ-mas my true love gave to me six geese a - lay - ing
seventh se-ven swans a - swim - ming, (to 6)
eight eight maids a - milk - ing, (to 7)
ninth nine lad - ies dan - cing, (to 8)
tenth ten lords a - leap - ing, (to 9)
elev enth elev - en pi - pers pi - ping, (to 10)
twelfth twelve drum-mers drum - ming, (to 11)

five gold ___ rings, four ___ cal - ling birds,

three French hens, two ___ tur - tle doves, and a

Six times *Last time*

par - tridge ___ in a pear tree. On the tree.